THE EASTER STORY

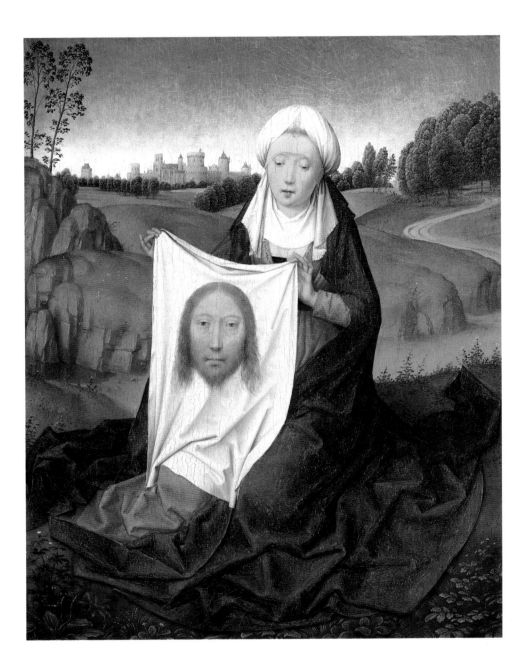

The Easter Story

NATIONAL GALLERY
OF ART
WASHINGTON

A BULFINCH PRESS BOOK

LITTLE, BROWN AND COMPANY

BOSTON · TORONTO · LONDON

First Edition

Library of Congress Cataloging-in-Publication Data

The Easter story / National Gallery of Art.—1st ed.

p. cm.

"A Bulfinch Press book."

ISBN 0-8212-1978-2

1. Jesus Christ—Passion Week—Art.

2. Jesus Christ in fiction, drama, poetry, etc.

3. National Gallery of Art (U.S.)

I. National Gallery of Art (U.S.)

N8052.4.E17 1993

755'.53—dc20 92-19505

Bulfinch Press is an imprint and trademark of Little, Brown and Company (Inc.)

Published simultaneously in Canada by Little, Brown & Company (Canada) Limited

PRINTED IN JAPAN

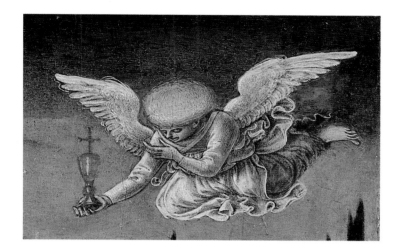

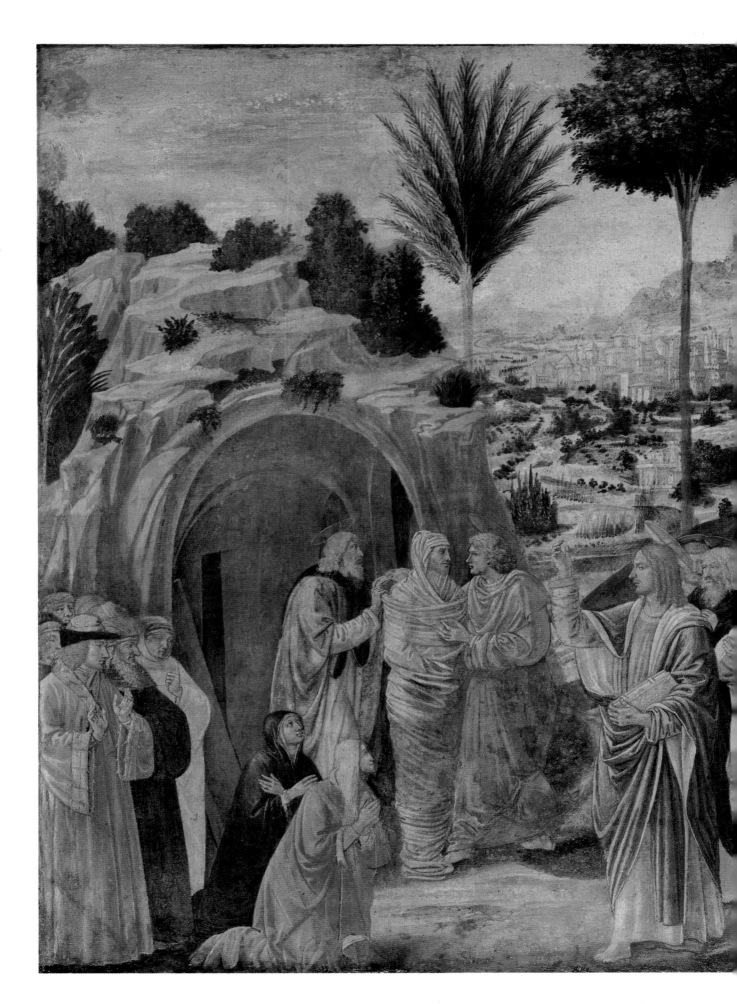

8

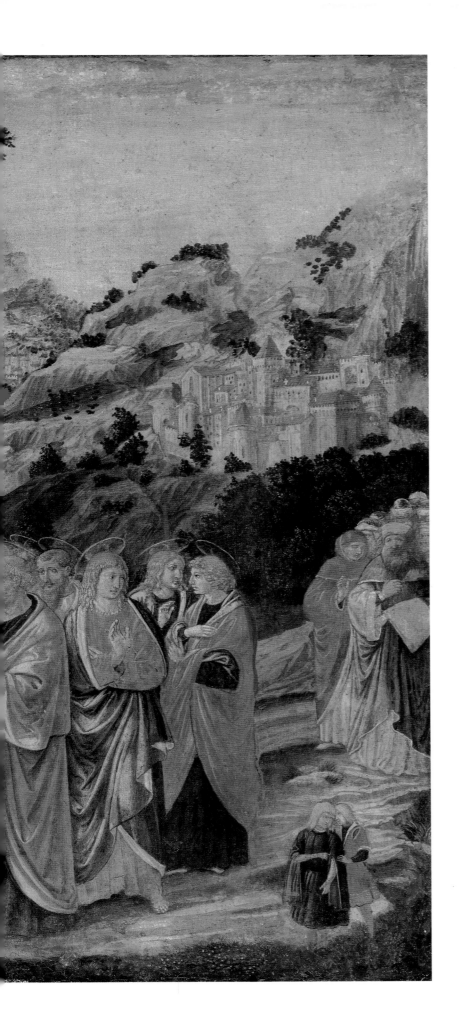

*Now a certain man
was sick, named Lazarus, of
Bethany, the town of Mary
and her sister Martha. . . .
Therefore his sisters sent unto
him, saying, Lord, behold,
he whom thou lovest is sick.
When Jesus heard that, he
said, This sickness is not unto
death, but for the glory of
God, that the Son of God
might be glorified thereby. . . .*

*Then when Jesus
came, he found that he had
lain in the grave four days
already. . . . Then said Martha
unto Jesus, Lord if thou hadst
been here, my brother had
not died. But I know, that even
now, whatsoever thou wilt
ask of God, God will give it
thee. Jesus saith unto her,
Thy brother shall rise again.
Martha saith unto him, I
know that he shall rise again
in the resurrection at the
last day. Jesus said unto her,
I am the resurrection, and
the life: he that believeth in
me, though he were dead, yet
shall he live: And whosoever
liveth and believeth in me
shall never die. Believest thou
this? She saith unto him, Yea,
Lord: I believe that thou art
the Christ, the Son of God,
which should come into the
world. . . .*

9

Then when Mary was come where Jesus was, and saw him, she fell down at his feet, saying unto him, Lord, if thou hadst been here, my brother had not died. When Jesus therefore saw her weeping, and the Jews also weeping which came with her, he groaned in the spirit and was troubled, And said, Where have ye laid him? They said unto him, Lord, come and see. Jesus wept.

Then said the Jews, Behold how he loved him! And some of them said, Could not this man, which opened the eyes of the blind, have caused that even this man should not have died?

Jesus therefore again groaning in himself cometh to the grave. It was a cave, and a stone lay upon it. Jesus said, Take ye away the stone. . . . And Jesus lifted up his eyes, and said, Father, I thank thee that thou hast heard me. And I knew that thou hearest me always: but because of the people which stand by I said it, that they may believe that thou hast sent me. And when he thus had spoken, he cried with a loud voice, Lazarus, come forth. And he that was dead came forth, bound hand and foot with graveclothes: and his face was bound about with a napkin. Jesus saith unto them, Loose him, and let him go.

IF I MIGHT only love my God and die!

But now He bids me love Him and live on,

Now when the bloom of all my life is gone,

The pleasant half of life has quite gone by.

My tree of hope is lopped that spread so high;

And I forget how summer glowed and shone,

While autumn grips me with its fingers wan,

And frets me with its fitful windy sigh.

When autumn passes then must winter numb,

And winter may not pass a weary while,

But when it passes spring shall flower again:

And in that spring who weepeth now shall smile,

Yea, they shall wax who now are on the wane,

Yea, they shall sing for love when Christ shall come.

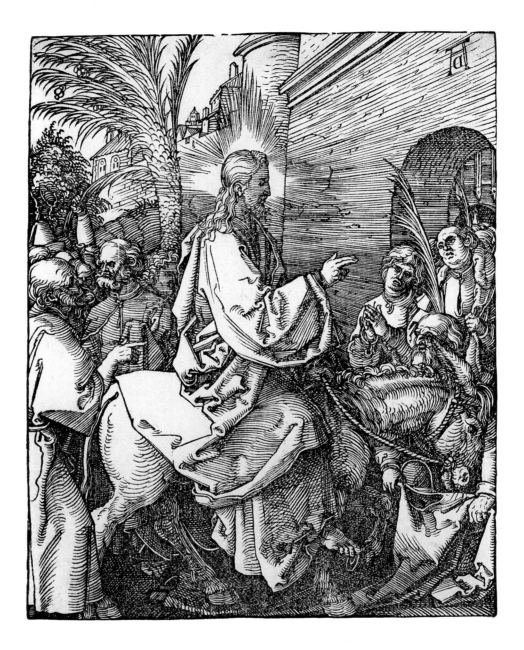

12

And when they came nigh to Jerusalem, unto Bethphage and Bethany, at the mount of Olives, he sendeth forth two of his disciples, And saith unto them, Go your way into the village over against you: and as soon as ye be entered into it, ye shall find a colt tied, whereon never man sat; loose him, and bring him. And if any man say unto you, Why do ye this? say ye that the Lord hath need of him; and straightway he will send him hither. And they went their way, and found the colt tied by the door without in a place where two ways met; and they loose him. And certain of them that stood there said unto them, What do ye, loosing the colt? And they said unto them even as Jesus had commanded: and they let them go.

And they brought the colt to Jesus, and cast their garments on him; and he sat upon him. And many spread their garments in the way: and others cut down branches off the trees, and strawed them in the way. And they that went before, and they that followed, cried, saying, Hosanna; Blessed is he that cometh in the name of the Lord: Blessed be the kingdom of our father David, that cometh in the name of the Lord: Hosanna in the highest.

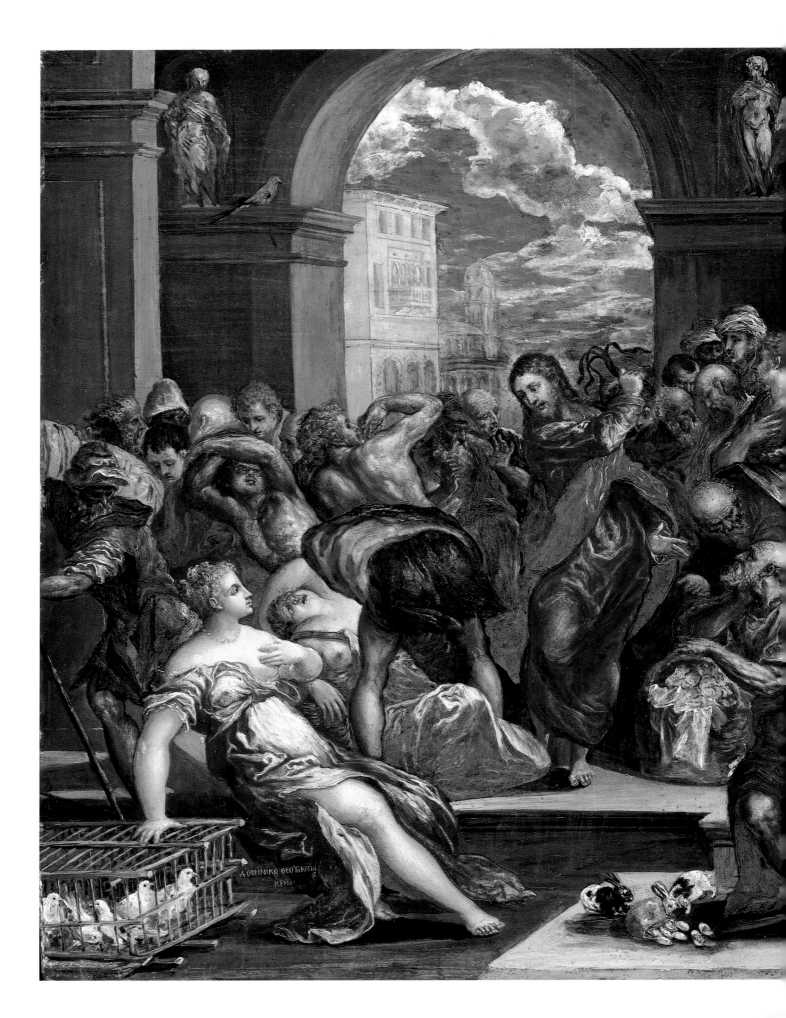

And Jesus went into the temple of God, and cast out all them that sold and bought in the temple, and overthrew the tables of the money-changers, and the seats of them that sold doves, And said unto them, It is written, My house shall be called the house of prayer; but ye have made it a den of thieves.

15

Now before the feast of the passover, when Jesus knew that his hour was come that he should depart out of this world unto the Father, having loved his own which were in the world, he loved them unto the end.

And he sent Peter and John, saying, Go and prepare us the passover, that we may eat. And they said unto him, Where wilt thou that we prepare? And he said unto them, Behold, when ye are entered into the city, there shall a man meet you, bearing a pitcher of water; follow him into the house where he entereth in. And ye shall say unto the goodman of the house, The Master saith unto thee, Where is the guest-chamber, where I shall eat the passover with my disciples? And he shall shew you a large upper room furnished: there make ready. And they went, and found as he had said unto them: and they made ready the passover.

16

ND THE LORD SPAKE UNTO Moses and Aaron in the land of Egypt, saying, This month shall be unto you the beginning of months: it shall be the first month of the year to you. Speak ye unto all the congregation of Israel, saying, In the tenth day of this month they shall take to them every man a lamb, according to the house of their fathers, a lamb for an house. . . . Your lamb shall be without blemish, a male of the first year: ye shall take it out from the sheep, or from the goats: And ye shall keep it up until the fourteenth day of the same month: and the whole assembly of the congregation of Israel shall kill it in the evening. And they shall take of the blood, and strike it on the two side posts and on the upper door post of the houses, wherein they shall eat it.

ND THUS ye shall eat it; with your loins girded, your shoes on your feet, and your staff in your hand; and ye shall eat it in haste: it is the Lord's passover. For I will pass through the land of Egypt this night, and will smite all the firstborn in the land of Egypt, both man and beast; and against all the gods of Egypt I will execute judgment: I am the Lord. And the blood shall be to you for a token upon the houses where ye are: and when I see the blood, I will pass over you and the plague shall not be upon you to destroy you, when I smite the land of Egypt. And this day shall be unto you for a memorial; and ye shall keep it a feast to the Lord throughout your generations; ye shall keep it a feast by an ordinance for ever.

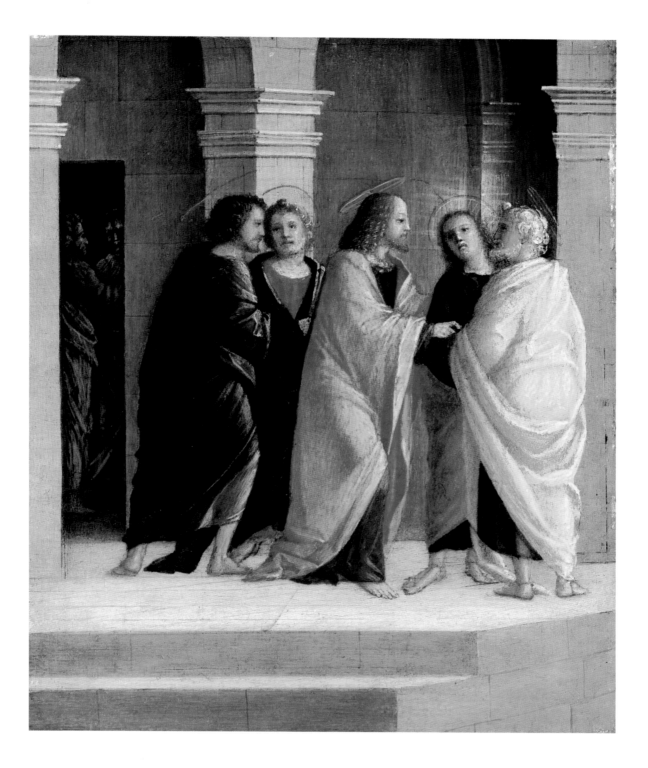

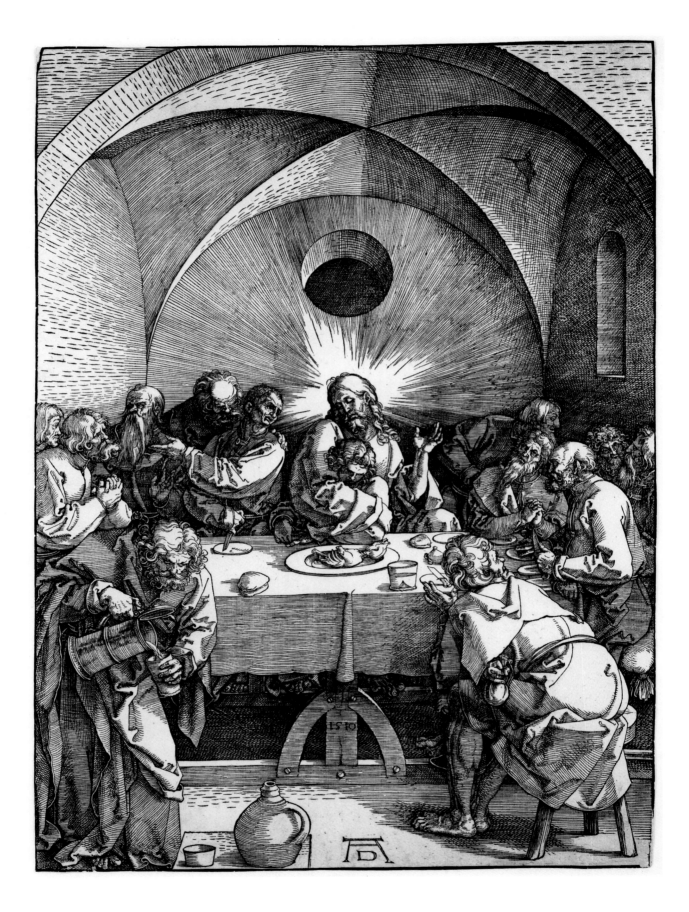

And when the hour was come, he sat down, and the twelve apostles with him. And he said unto them, With desire I have desired to eat this passover with you before I suffer: For I say unto you, I will not any more eat thereof, until it be fulfilled in the kingdom of God. And he took the cup, and gave thanks, and said, Take this, and divide it among yourselves: For I say unto you, I will not drink of the fruit of the vine, until the kingdom of God shall come.

And he took bread, and gave thanks, and brake it, and gave unto them, saying, This is my body which is given for you: this do in remembrance of me. Likewise also the cup after supper, saying, This cup is the new testament in my blood, which is shed for you.

19

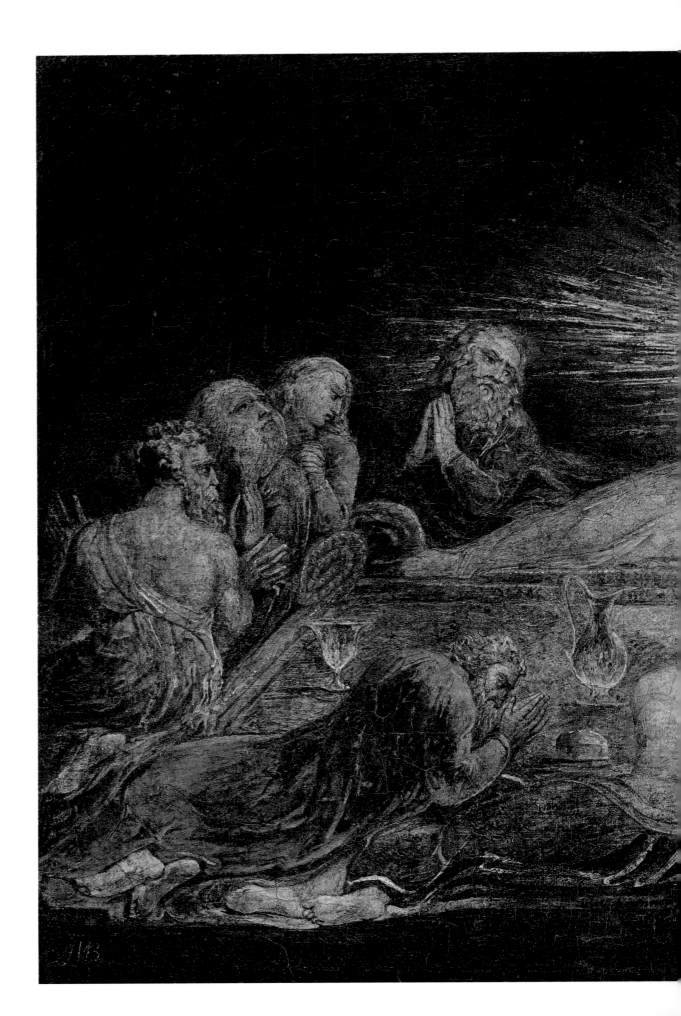

20

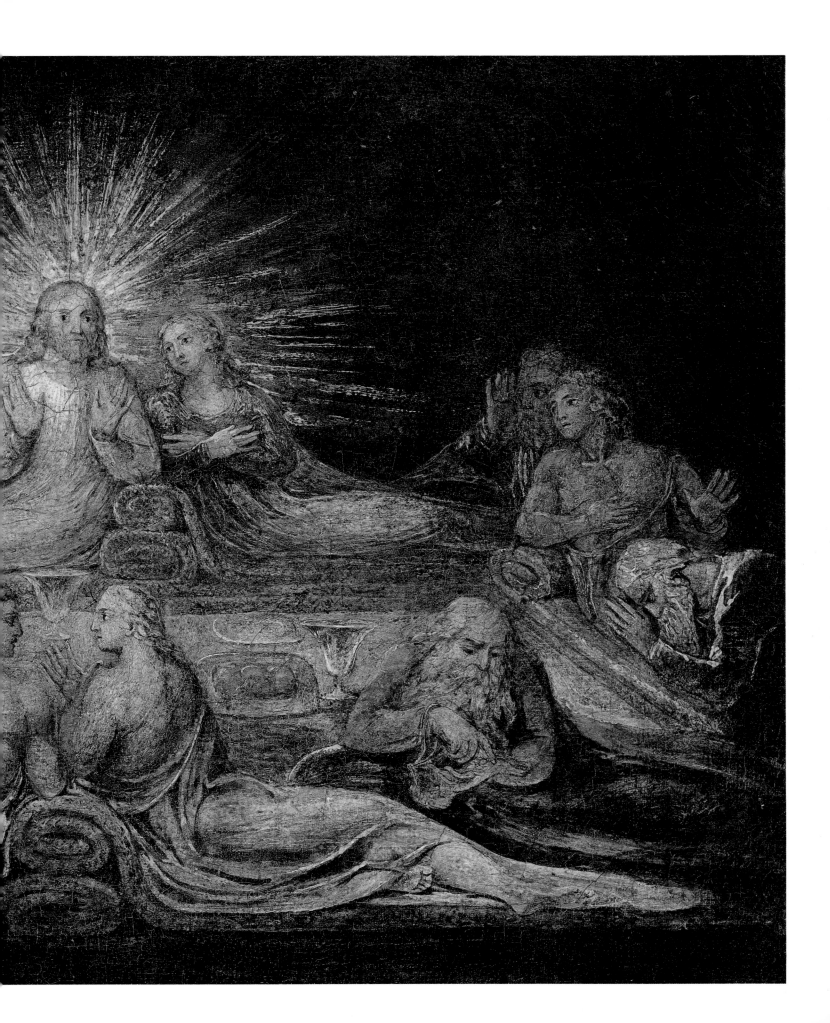

He riseth from supper, and laid aside his garments and took a towel, and girded himself. After that he poureth water into a basin, and began to wash the disciples' feet, and to wipe them with the towel wherewith he was girded.

So after he had washed their feet, and had taken his garments, and was set down again, he said unto them, Know ye what I have done to you? Ye call me Master and Lord: and ye say well; for so I am. If I then, your Lord and Master, have washed your feet; ye also ought to wash one another's feet. For I have given you an example, that ye should do as I have done to you. Verily, verily, I say unto you, The servant is not greater than his lord; neither he that is sent greater than he that sent him. If ye know these things, happy are ye if ye do them.

A new commandment I give unto you, That ye love one another; as I have loved you, that ye also love one another. By this shall all men know that ye are my disciples, if ye have love one to another.

When Jesus had thus said, he was troubled in spirit, and testified, and said, Verily, verily, I say unto you, that one of you shall betray me.

Then the disciples looked one on another, doubting of whom he spake. Now there was leaning on Jesus' bosom one of his disciples, whom Jesus loved. Simon Peter therefore beckoned to him, that he should ask who it should be of whom he spake. He then lying on Jesus' breast saith unto him, Lord who is it?

Jesus answered, He it is, to whom I shall give a sop, when I have dipped it. And when he had dipped the sop, he gave it to Judas Iscariot, the son of Simon. And after the sop Satan entered into him. Then said Jesus unto him, That thou doest, do quickly.

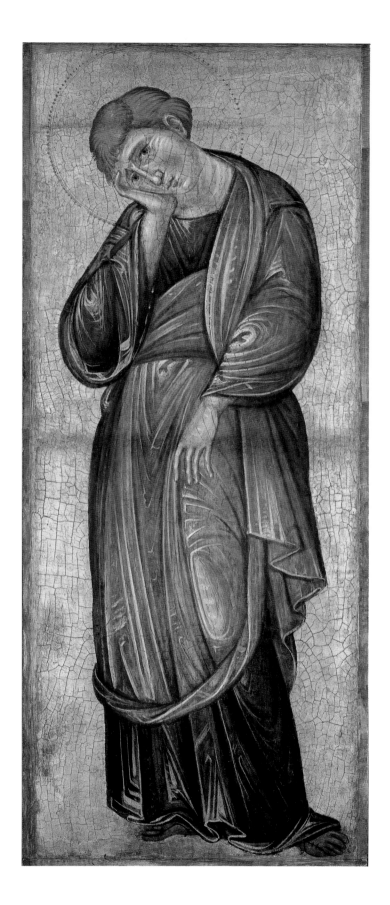

23

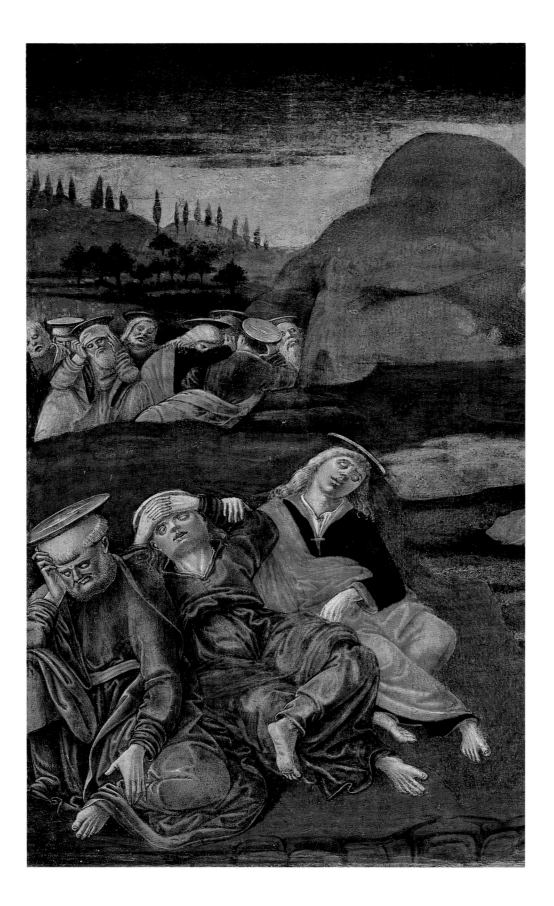

And they came to a place which was named Gethsemane: and he saith to his disciples, Sit ye here, while I shall pray. And he taketh with him Peter and James and John, and began to be sore amazed, and to be very heavy; And saith unto them, My soul is exceeding sorrowful unto death: tarry ye here and watch.

And he went forward a little, and fell on the ground, and prayed that, if it were possible, the hour might pass from him. And he said, Abba, Father, all things are possible unto thee; take away this cup from me: nevertheless not what I will, but what thou wilt.

And he cometh, and findeth them sleeping, and saith unto Peter, Simon, sleepest thou? couldest not thou watch one hour? Watch ye and pray, lest ye enter into temptation. The spirit truly is ready, but the flesh is weak. And again he went away, and prayed, and spake the same words. And when he returned, he found them asleep again, (for their eyes were heavy,) neither wist they what to answer him.

And he cometh the third time, and saith unto them, Sleep on now, and take your rest: it is enough, the hour is come; behold the Son of man is betrayed into the hands of sinners.

Simon Peter said unto him, Lord, whither goest thou? Jesus answered him, Whither I go, thou canst not follow me now; but thou shalt follow me afterwards. Peter said unto him, Lord why cannot I follow thee now? I will lay down my life for thy sake.

Jesus answered him, Wilt thou lay down thy life for my sake? Verily, verily, I say unto thee, The cock shall not crow, till thou hast denied me thrice.

25

And immediately, while he yet spake, cometh Judas, one of the twelve, and with him a great multitude with swords and staves, from the chief priests and the scribes and the elders.

And he that betrayed him had given them a token, saying, Whomsoever I shall kiss, that same is he; take him, and lead him away safely. And as soon as he was come, he goeth straightway to him, and saith, Master, master; and kissed him.

But Jesus said unto him, Judas, betrayest thou the Son of man with a kiss?

And they laid their hands on him, and took him.

Then they took him, and led him and brought him into the high priest's house. And Peter followed afar off. And when they had kindled a fire in the midst of the hall, and were set down together, Peter sat down among them. But a certain maid beheld him as he sat by the fire, and earnestly looked upon him, and said, This man was also with him. And he denied him, saying, Woman, I know him not.

And after a little while another saw him, and said, Thou art also of them. And Peter said, Man, I am not. And about the space of one hour after another confidently affirmed, saying, Of a truth this fellow also was with him: for he is a Galilaean. And Peter said, Man, I know not what thou sayest. And immediately, while he yet spake, the cock crew.

And the Lord turned, and looked upon Peter. And Peter remembered the word of the Lord, how he had said unto him, Before the cock crow, thou shalt deny me thrice. And Peter went out, and wept bitterly.

Then Simon Peter having a sword drew it, and smote the high priest's servant, and cut off his right ear. The servant's name was Malchus.

And Jesus answered and said, Suffer ye thus far. And touched his ear, and healed him. Then Jesus said unto the chief priests, and captains of the temple, and the elders, which were come to him, Be ye come out, as against a thief, with swords and staves? When I was daily with you in the temple, ye stretched forth no hands against me: but this is your hour, and the power of darkness.

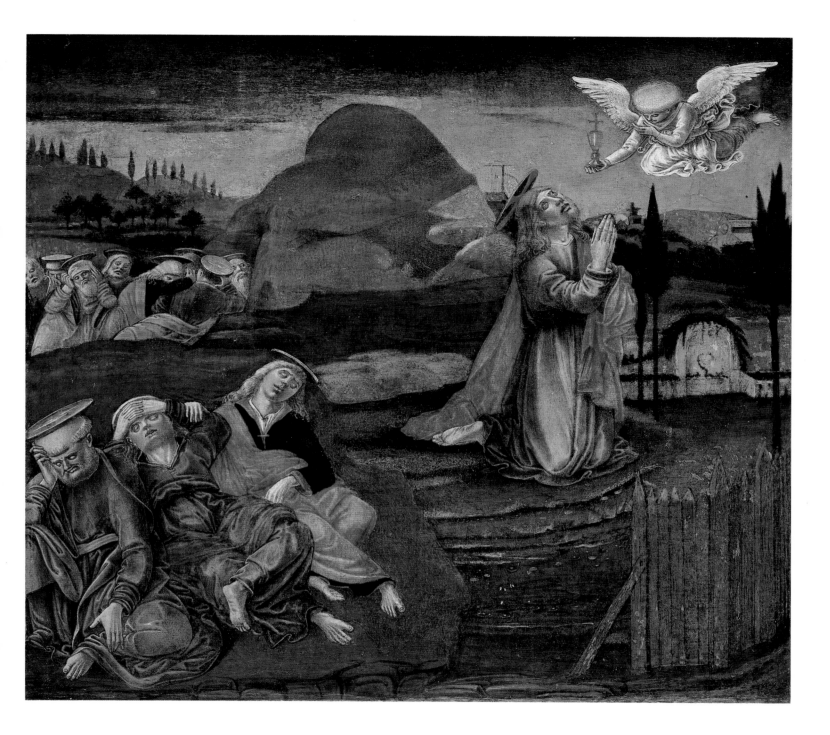

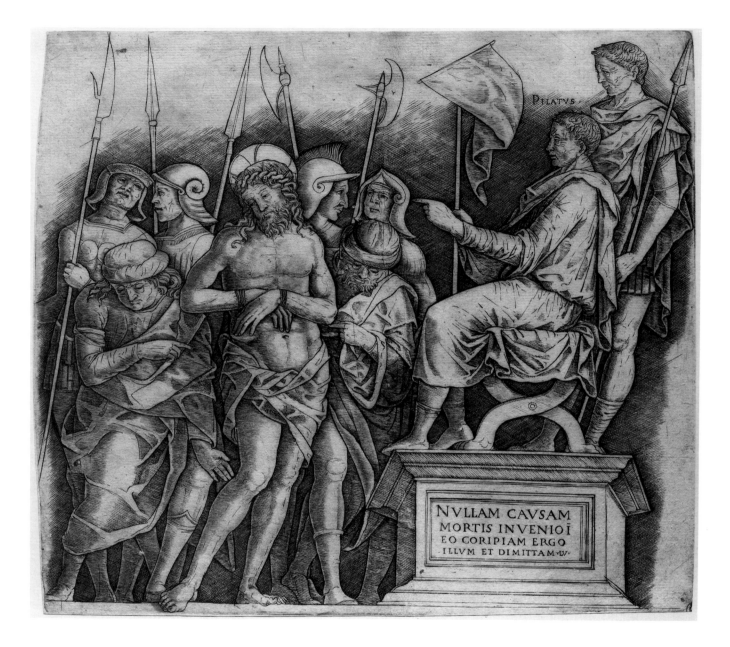

PILATVS

NVLLAM CAVSAM
MORTIS INVENIO Ī
EO CORIPIAM ERGO
ILLVM ET DIMITTAM ·LV·

28

And the high priest stood up in the midst, and asked Jesus, saying, Answerest thou nothing? what is it which these witness against thee? But he held his peace, and answered nothing. Again the high priest asked him, and said unto him, Art thou the Christ, the Son of the Blessed? And Jesus said, I am: and ye shall see the Son of man sitting on the right hand of power, and coming in the clouds of heaven. Then the high priest rent his clothes and saith, What need we any further witnesses? Ye have heard the blasphemy: what think ye? And they all condemned him to be guilty of death.

When the morning was come, all the chief priests and elders of the people took counsel against Jesus to put him to death: And when they had bound him, they led him away, and delivered him to Pontius Pilate the governor. . . .

And Jesus stood before the governor: and the governor asked him, saying, Art thou the King of the Jews? And Jesus said unto him, Thou sayest. And when he was accused of the chief priests and elders, he answered nothing. . . .

Pilate saith unto them, What shall I do then with Jesus which is called Christ? They all say unto him, Let him be crucified. And the governor said, Why, what evil hath he done? But they cried out the more, saying, Let him be crucified.

When Pilate saw that he could prevail nothing, but that rather a tumult was made, he took water, and washed his hands before the multitude, saying, I am innocent of the blood of this just person: see ye to it.

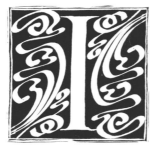 AM FEEBLE AND SORE BROKEN: I have roared by reason of the disquietness of my heart. Lord, all my desire is before thee; and my groaning is not hid from thee. My heart panteth, my strength faileth me: as for the light of mine eyes, it also is gone from me. My lovers and my friends stand aloof from my sore; and my kinsmen stand afar off. They also that seek after my life lay snares for me: and they that seek my hurt speak mischievous things, and imagine deceits all the day long. But I, as a deaf man, heard not; and I was as a dumb man that openeth not his mouth. Thus I was as a man that heareth not, and in whose mouth are no reproofs. For in thee,

O Lord, do I hope: thou wilt hear,

O Lord my God.

Then Pilate therefore took Jesus, and scourged him. And the soldiers platted a crown of thorns, and put it on his head, and they put on him a purple robe. And said, Hail, King of the Jews! and they smote him with their hands.

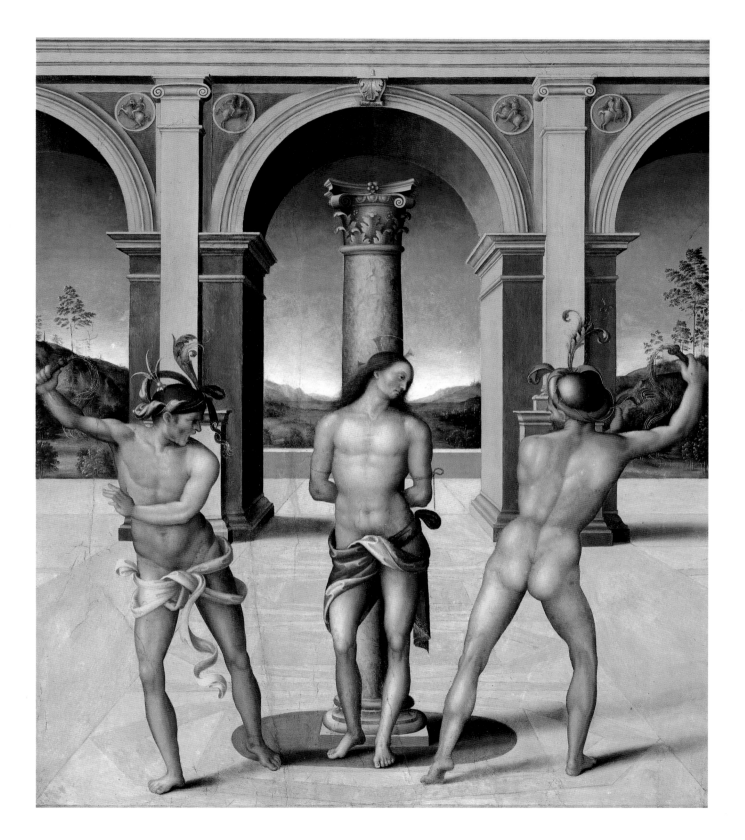

32

OR NOW to sorrow must I tune my song,

And set my harp to notes of saddest woe,

Which on our dearest Lord did seize ere long,

Dangers, and snares, and wrongs, and worse than so,

Which he for us did freely undergo.

 Most perfect hero, tried in heaviest plight

Of labours huge and hard, too hard for human wight.

He sovereign priest stooping his regal head

That dropped with odorous oil down his fair eyes,

Poor fleshly tabernacle enterèd,

His starry front low-roofed beneath the skies;

O what a mask was there, what a disguise!

 Yet more; the stroke of death he must abide,

Then lies him meekly down fast by his brethren's side.

Pilate therefore went forth again and saith unto them, Behold, I bring him forth to you, that ye may know that I find no fault in him. Then came Jesus forth, wearing the crown of thorns, and the purple robe. And Pilate saith unto them, Behold the man!

BY MIRACLES exceeding power of man,

He faith in some, envy in some begat,

For, what weak spirits admire, ambitious hate;

In both affections many to him ran,

But oh! the worst are most, they will and can,

Alas, and do, unto the immaculate,

Whose creature Fate is, now prescribe a fate,

Measuring self-life's infinity to a span,

Nay to an inch. Lo, where condemned he

Bears his own cross, with pain, yet by and by

When it bears him, he must bear more and die.

Now thou art lifted up, draw me to thee,

And at thy death giving such liberal dole,

Moist, with one drop of thy blood, my dry soul.

Then delivered he him therefore unto them to be crucified. And they took Jesus, and led him away. And he bearing his cross went forth into a place called the place of a skull, which is called in the Hebrew Golgotha.

34

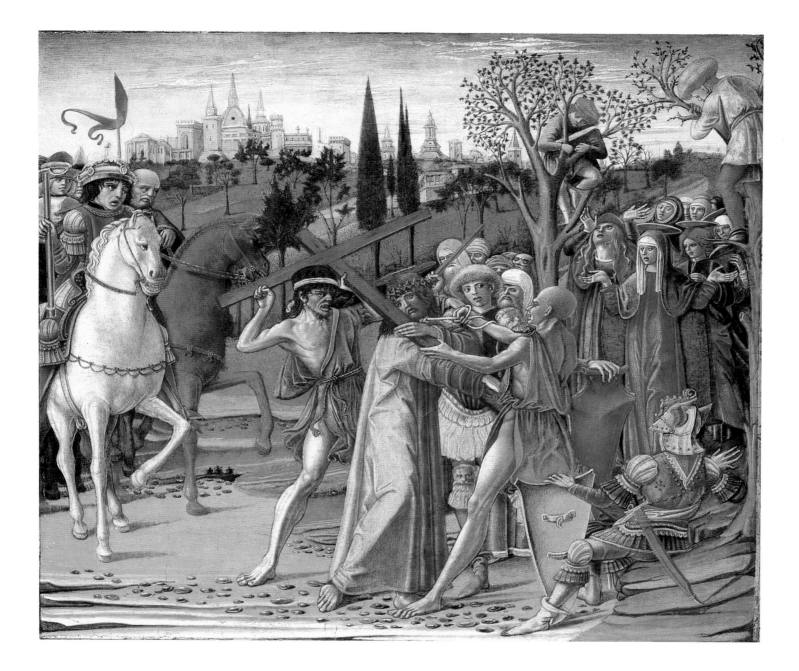

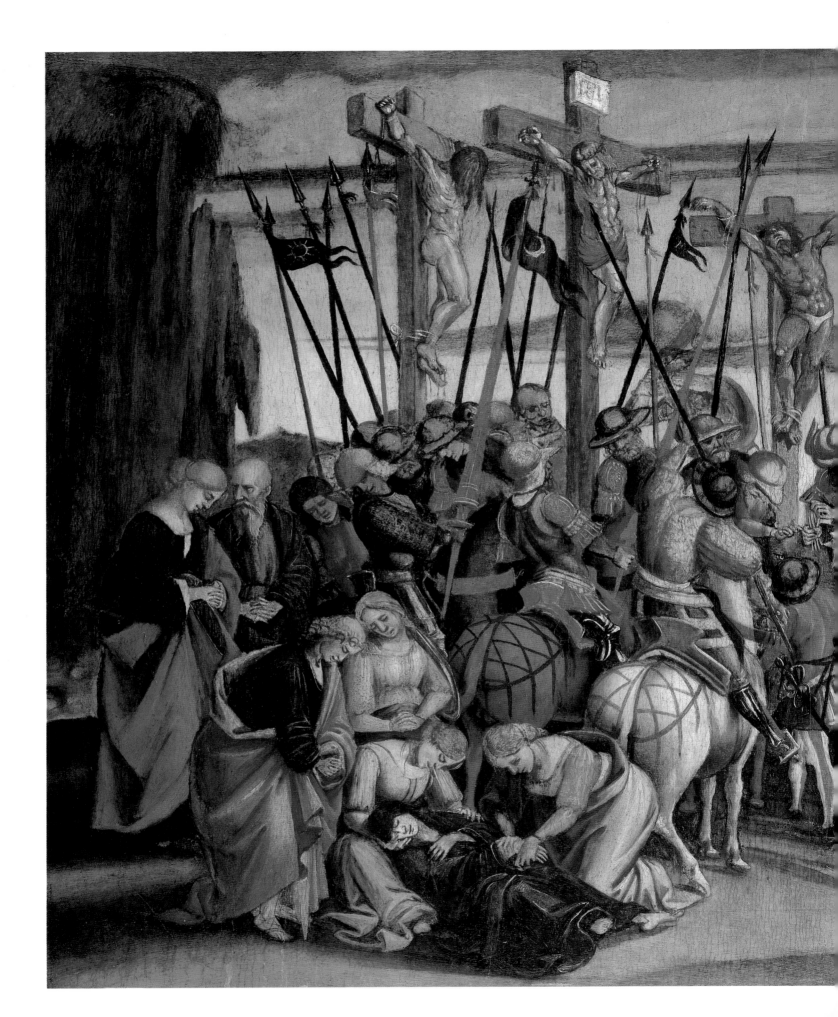

And when they were come to the place, which is called Calvary, there they crucified him, and the male-factors, one on the right hand, and the other on the left. Then said Jesus, Father, forgive them; for they know not what they do. And they parted his raiment, and cast lots.

And the people stood beholding. And the rulers also with them derided him, saying, He saved others; let him save himself, if he be Christ, the chosen of God. And the soldiers also mocked him, coming to him, and offering him vinegar, And saying, If thou be the king of the Jews, save thyself.

And a superscription also was written over him in letters of Greek, and Latin, and Hebrew, **THIS IS THE KING OF THE JEWS.**

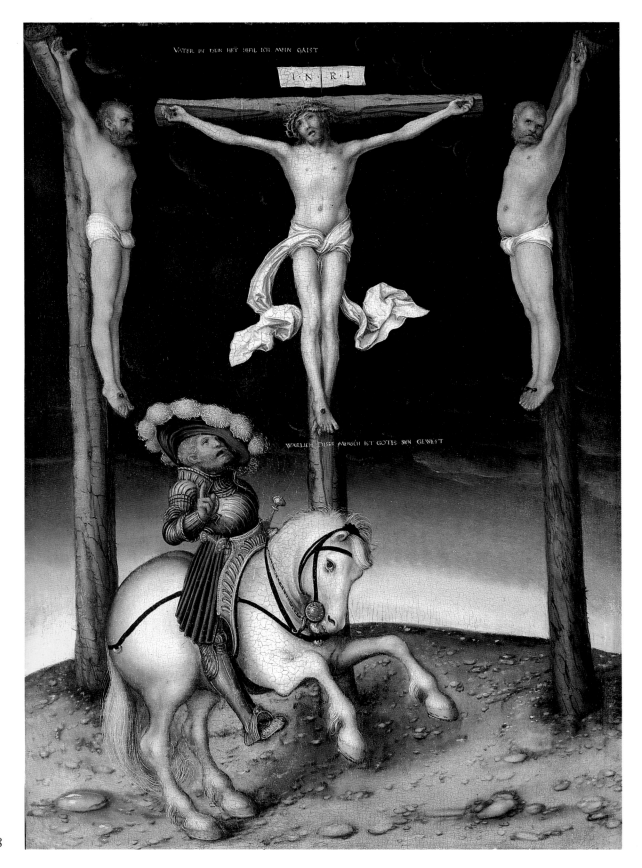

*H*AVING been tenant long to a rich Lord,

Not thriving, I resolved to be bold,

And make a suit unto him, to afford

A new small-rented lease, and cancell th' old.

In heaven at his manour I him sought:

They told me there, that he was lately gone

About some land, which he had dearly bought

Long since on earth, to take possession.

I straight return'd, and knowing his great birth,

Sought him accordingly in great resorts;

In cities, theatres, gardens, parks, and courts:

At length I heard a ragged noise and mirth

Of theeves and murderers: there I him espied,

Who straight, *Your suit is granted,* said, & died.

I LEANT UPON a coppice gate
　　　When Frost was spectre-gray,
And Winter's dregs made desolate
　　　The weakening eye of day.
The tangled bine-stems scored the sky
　　　Like strings of broken lyres,
And all mankind that haunted nigh
　　　Had sought their household fires.

The land's sharp features seemed to be
　　　The Century's corpse outleant,
His crypt the cloudy canopy,
　　　The wind his death-lament.
The ancient pulse of germ and birth
　　　Was shrunken hard and dry,
And every spirit upon earth
　　　Seemed fervourless as I.

When the even was come, there came a rich man of Arimathaea, named Joseph, who also himself was Jesus' disciple: He went to Pilate, and begged the body of Jesus. Then Pilate commanded the body to be delivered. And when Joseph had taken the body, he wrapped it in a clean linen cloth.

At once a voice arose among
　　　The bleak twigs overhead
In a full-hearted evensong
　　　Of joy illimited;
An aged thrush, frail, gaunt, and small,
　　　In blast-beruffled plume,
Had chosen thus to fling his soul
　　　Upon the growing gloom.

So little cause for carollings
　　　Of such ecstatic sound
Was written on terrestrial things
　　　Afar or nigh around,

That I could think there trembled through
　　　His happy good-night air
Some blessed Hope, whereof he knew
　　　And I was unaware.

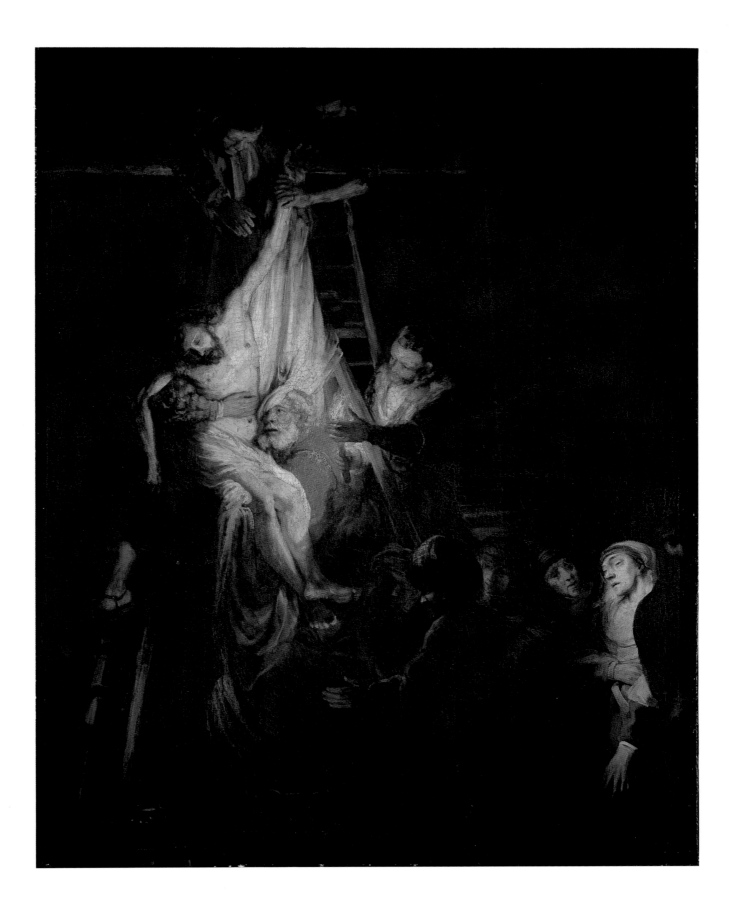

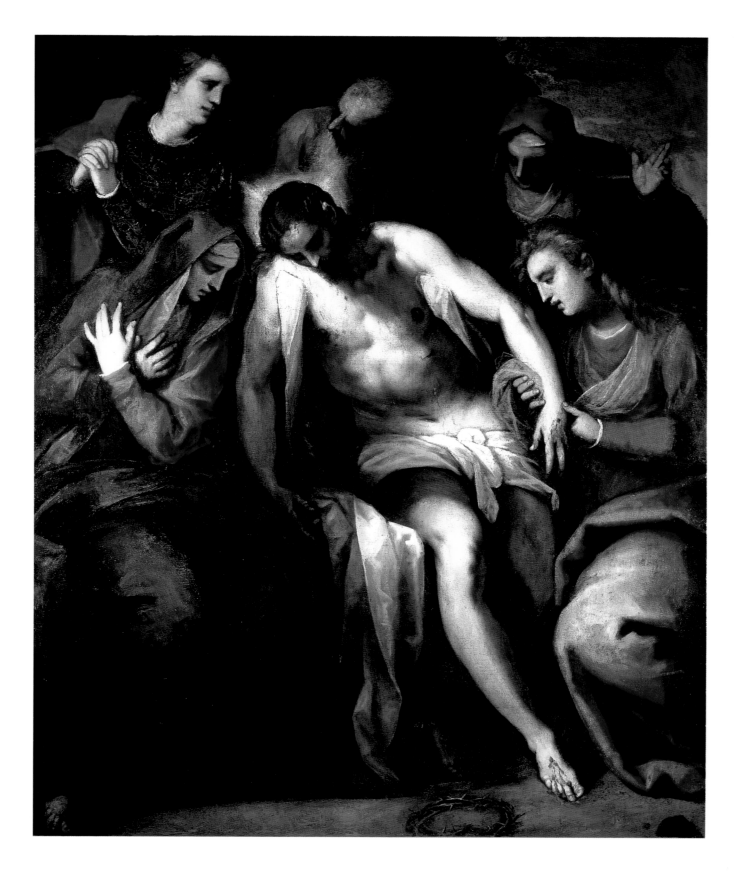

ALL NIGHT had shout of men and cry

 Of woeful women filled his way;

Until that noon of sombre sky

 On Friday, clamour and display

Smote him; no solitude had he,

No silence, since Gethsemane.

Public was Death; but Power, but Might,

 But Life again, but Victory,

Were hushed within the dead of night,

 The shuttered dark, the secrecy.

And all alone, alone, alone,

He rose again behind the stone.

E THOU then, O thou dear

Mother, my atmosphere;

My happier world, wherein

To wend and meet no sin;

Above me, round me lie

Fronting my froward eye

With sweet and scarless sky;

Stir in my ears, speak there

Of God's love, O live air,

Of patience, penance, prayer:

World-mothering air, air wild,

Wound with thee, in thee isled,

Fold home, fast fold thy child.

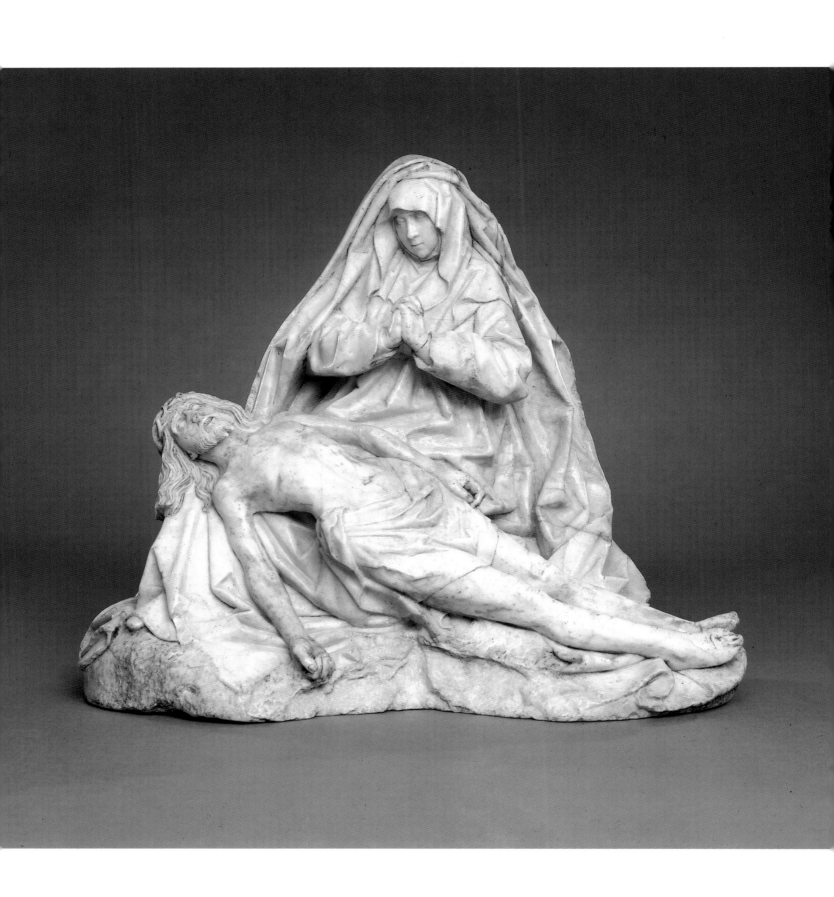

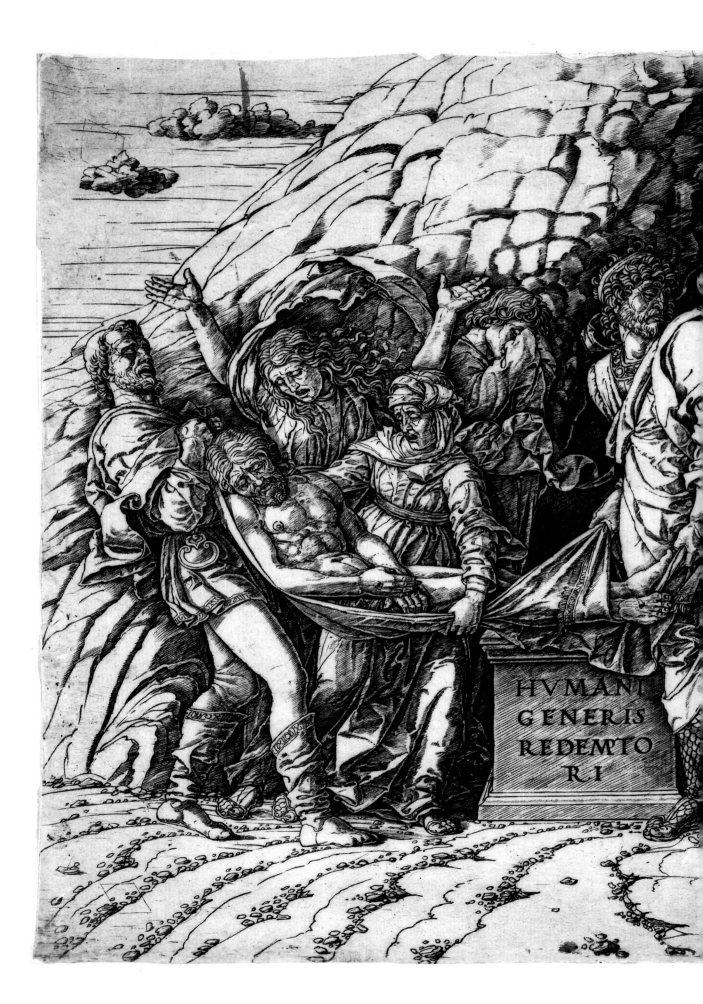

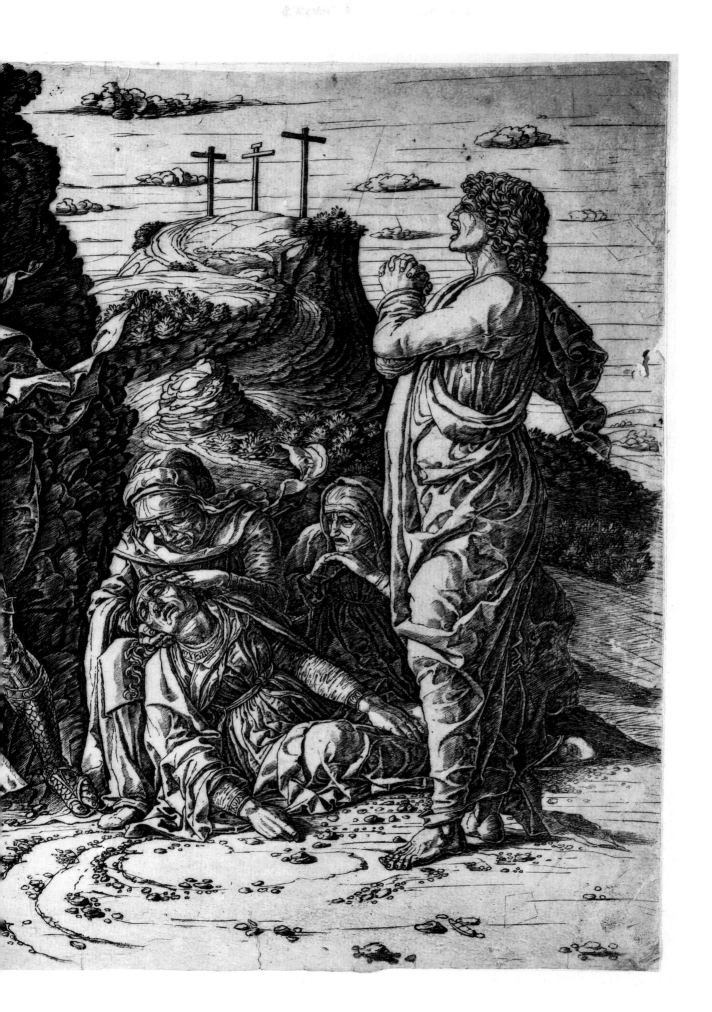

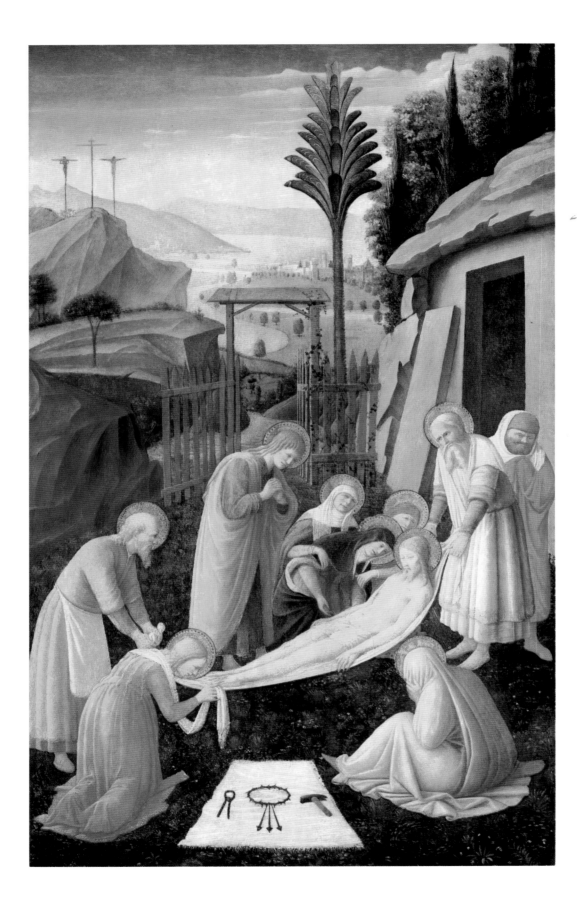

48

*I*F IN that Syrian garden, ages slain,

You sleep, and know not you are dead in vain,

Nor even in dreams behold how dark and bright

Ascends in smoke and fire by day and night

The hate you died to quench and could but fan,

Sleep well and see no morning, son of man.

But if, the grave rent and the stone rolled by,

At the right hand of majesty on high

You sit, and sitting so remember yet

Your tears, your agony and bloody sweat,

Your cross and passion and the life you gave,

Bow hither out of heaven and see and save.

Now in the place where he was crucified there was a garden; and in the garden a new sepulchre, wherein was never man yet laid. There laid they Jesus therefore because of the Jews' preparation day; for the sepulchre was nigh at hand.

49

*T*HE wintry winds have ceased to blow,

 And trembling leaves appear;

And fairest flowers succeed the snow,

 And hail the infant year.

So, when the world and all its woes

 Are vanish'd far away,

Fair scenes and wonderful repose

 Shall bless the new-born day,—

When, from the confines of the grave,

 The body too shall rise;

No more precarious passion's slave,

 Nor error's sacrifice.

'Tis but a sleep—and Sion's king

 Will call the many dead:

'Tis but a sleep—and then we sing,

 O'er dreams of sorrow fled.

Yes!—wintry winds have ceased to blow,

 And trembling leaves appear,

And Nature has her types to show

 Throughout the varying year.

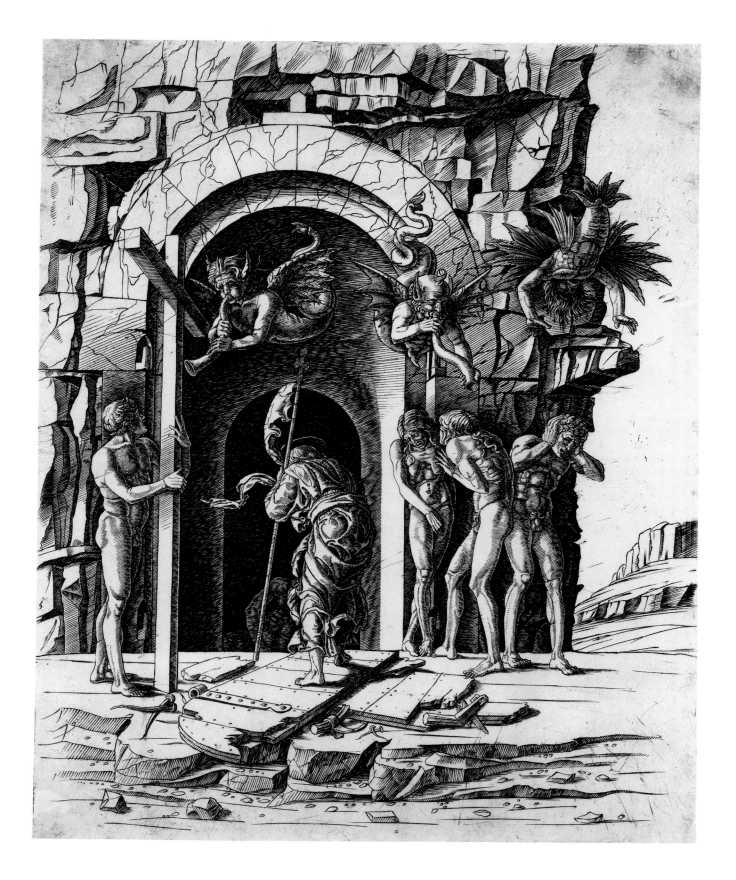

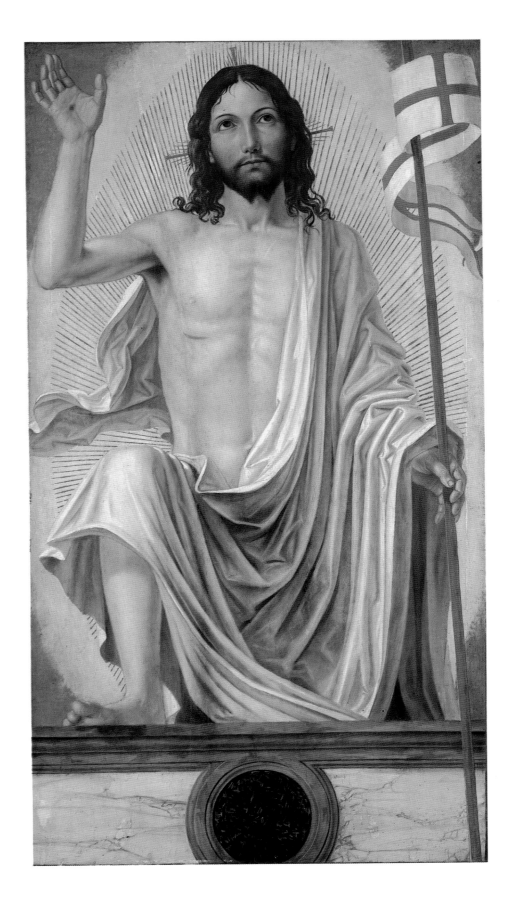

52

In the end of the sabbath, as it began to dawn toward the first day of the week, came Mary Magdalene and the other Mary to see the sepulchre.

And, behold, there was a great earthquake: for the angel of the Lord descended from heaven, and came and rolled back the stone from the door, and sat upon it. His countenance was like lightning, and his raiment white as snow: And for fear of him the keepers did shake, and became as dead men.

And the angel answered and said unto the women, Fear not ye: for I know that ye seek Jesus, which was crucified. He is not here: for he is risen, as he said. Come, see the place where the Lord lay.

E HATH abolished the old drouth,

And rivers run where all was dry,

The field is sopped with merciful dew.

He hath put a new song in my mouth,

The words are old, the purport new,

And taught my lips to quote this word

That I shall live, I shall not die,

But I shall when the shocks are stored

See the salvation of the Lord.

53

But Mary stood without at the sepulchre weeping: and as she wept, she stooped down, and looked into the sepulchre, And seeth two angels in white sitting, the one at the head, and the other at the feet, where the body of Jesus had lain. And they say unto her, Woman, why weepest thou? She saith unto them, Because they have taken away my Lord, and I know not where they have laid him.

And when she had thus said, she turned herself back, and saw Jesus standing, and knew not that it was Jesus. Jesus saith unto her, Woman, why weepest thou? whom seekest thou? She, supposing him to be the gardener, saith unto him, Sir, if thou have borne him hence, tell me where thou hast laid him, and I will take him away.

Jesus saith unto her, Mary. She turned herself, and saith unto him, Rabboni; which is to say, Master. Jesus saith unto her, Touch me not; for I am not yet ascended to my Father: but go to my brethren, and say unto them, I ascend unto my Father, and your Father; and to my God, and your God.

Mary Magdalene came and told the disciples that she had seen the Lord, and that he had spoken these things unto her.

ORD JESUS! with what sweetness and delights,

Sure, holy hopes, high joys and quick'ning flights

Dost thou feed thine! O thou! the hand that lifts

To him, who gives all good and perfect gifts.

Thy glorious, bright Ascension (though remov'd

So many ages from me) is so prov'd

And by thy spirit seal'd to me, that I

Feel me a sharer in thy victory.

 I soar and rise

 Up to the skies,

 Leaving the world their day,

 And in my flight,

 For the true light

 Go seeking all the way . . .

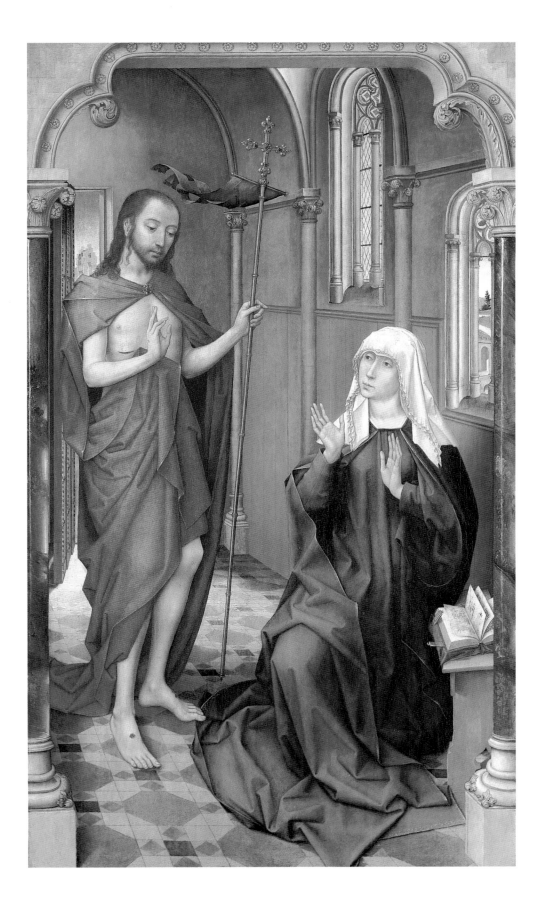

55

*M*OST glorious Lord of life, that on this day,

 didst make thy triumph over death and sin:

 and having harrowed hell, didst bring away

 captivity thence captive us to win:

This joyous day, dear Lord, with joy begin,

 and grant that we for whom thou diddest die

 being with thy dear blood clean washed from sin,

 may live for ever in felicity.

And that thy love we weighing worthily,

 may likewise love thee for the same again:

 and for thy sake that all like dear didst buy,

 with love may one another entertain.

So let us love, dear love, like as we ought,

 love is the lesson which the Lord us taught.

And when the day of Pentecost was fully come, they were all with one accord in one place. And suddenly there came a sound from heaven as of a rushing mighty wind, and it filled all the house where they were sitting.

And there appeared unto them cloven tongues like as of fire, and it sat upon each of them. And they were all filled with the Holy Ghost and began to speak with other tongues, as the Spirit gave them utterance.

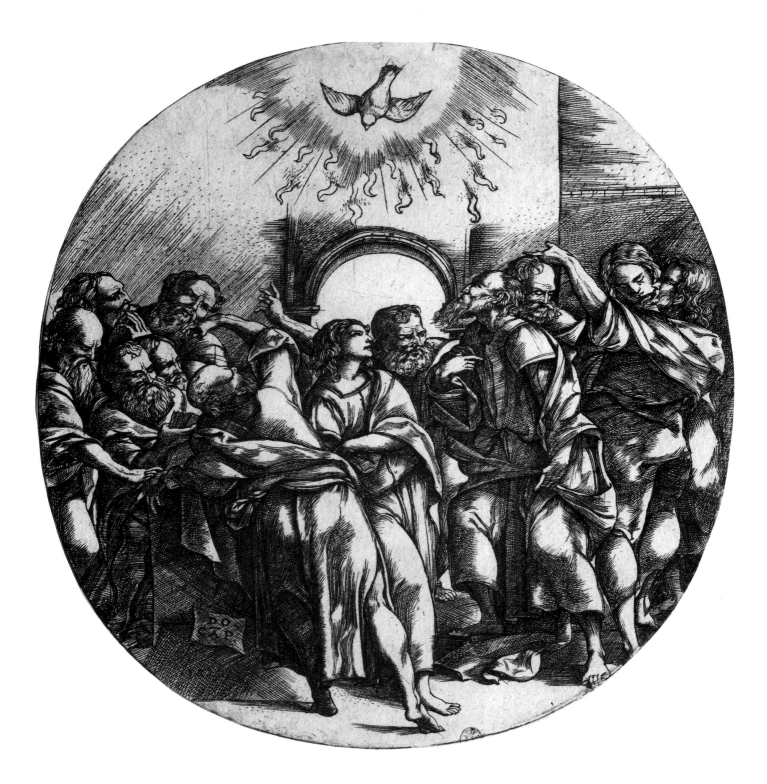

WAS a stricken deer, that left the herd

Long since; with many an arrow deep infixt

My panting side was charg'd, when I withdrew

To seek a tranquil death in distant shades.

There was I found by one who had himself

Been hurt by th' archers. In his side he bore,

And in his hands and feet, the cruel scars.

With gentle force soliciting the darts,

He drew them forth, and heal'd, and bade me live.

Since then, with few associates, in remote

And silent woods I wander, far from those

My former partners of the peopled scene;

With few associates, and not wishing more.

List of Works of Art

All works of art reproduced in The Easter Story *are in the collections of the National Gallery of Art, Washington, D.C.*

FRONT JACKET
Perugino, probably 1445–1523 Umbrian
The Crucifixion with the Virgin, Saint John, Saint Jerome, and Saint Mary Magdalene (middle panel), ca. 1485
Oil on panel transferred to canvas, 39⅞″ × 22¼″
Andrew W. Mellon Collection 1937.1.27.b

BACK JACKET
Bergognone, active 1481/1522 Lombard
The Resurrection, ca. 1510
Oil on panel, 45¼″ × 24¼″
Samuel H. Kress Collection 1952.5.1

PAGE 4
Hans Memling, active ca. 1465–1494 Bruges
Saint Veronica (obverse), ca. 1470/1475
Oil on panel, 11¹⁵⁄₁₆″ × 9″
Samuel H. Kress Collection 1952.5.46.a

PAGE 7
Benvenuto di Giovanni, 1436–ca. 1518 Sienese
The Agony in the Garden (detail), ca. 1490
From the *Passion of Our Lord*
Tempera on panel, 17″ × 19″
Samuel H. Kress Collection 1939.1.318

PAGES 8–9
Benozzo Gozzoli, 1420–1497 Florentine
The Raising of Lazarus, probably 1497
Oil on canvas, 25¾″ × 31¾″
Widener Collection 1942.9.24

PAGE 11
Attributed to Fra Angelico, ca. 1400–1455 Florentine
The Entombment (detail), ca. 1445
Tempera on panel, 35″ × 21⅝″
Samuel H. Kress Collection 1939.1.260

PAGE 12
Albrecht Dürer, 1471–1528 German
Christ's Entry into Jerusalem, probably ca. 1509/1510
From *The Small Woodcut Passion*
Woodcut, 5″ × 3⅞″
Rosenwald Collection 1943.3.3638

PAGES 14–15
El Greco (Domenikos Theotokopoulos), 1541–1614 Spanish
Christ Cleansing the Temple, probably before 1570

Oil on panel, 25¾″ × 32¾″
Samuel H. Kress Collection 1957.14.4

PAGE 17
Vincenzo Civerchio, ca. 1460/1470–probably 1544 Lombard
Christ Instructing Peter and John to Prepare for the Passover, 1504
Tempera on panel, 9⅜″ × 7⅝″
Samuel H. Kress Collection 1961.9.67

PAGE 18
Albrecht Dürer
The Last Supper, 1510
Woodcut from *The Large Passion,* 15½″ × 11³⁄₁₆″
Gift of W. G. Russell Allen 1941.1.23.(GR)

PAGES 20–21
William Blake, 1757–1827 British
The Last Supper, 1799
Oil on linen, 12″ × 19″
Rosenwald Collection 1954.13.1

PAGE 23
Master of the Franciscan Crucifixes, active second half
13th century Umbrian
Saint John the Evangelist, ca. 1272
Tempera on panel, 31⅝″ × 12½″
Samuel H. Kress Collection 1952.5.14

PAGE 24
Benvenuto di Giovanni
The Agony in the Garden (detail)
(see description for page 7)

PAGE 27
Benvenuto di Giovanni
The Agony in the Garden
(see description for page 7)

PAGE 28
Giovanni Antonio da Brescia, active ca. 1490–in or after
1525 Italian
Christ before Pilate, ca. 1500/1505
Engraving, 11⅜″ × 12⅜″
Rosenwald Collection 1943.3.438

PAGE 31
Bacchiacca, 1494–1557 Florentine
The Flagellation of Christ, ca. 1512/1515
Oil on panel, 22″ × 18⅞″
Samuel H. Kress Collection 1952.5.81

PAGE 32
Rembrandt van Rijn, 1606–1669 Dutch
Christ Presented to the People: Oblong Plate, 1655
Drypoint, 14¼₆″ × 17¹⁵⁄₁₆″ (plate); 14⅜″ × 18⁵⁄₁₆″ (sheet)
Rosenwald Collection 1945.5.109

PAGE 35
Benvenuto di Giovanni
Christ Carrying the Cross, ca. 1490
From the *Passion of Our Lord*
Tempera on panel, 17″ × 19″
Samuel H. Kress Collection 1952.5.52

PAGES 36–37
Luca Signorelli, probably 1441–1523 Umbrian
Calvary, probably ca. 1505
Tempera and oil on panel, 28⅜″ × 39½″
Samuel H. Kress Collection 1952.5.75

PAGE 38
Lucas Cranach, the Elder, 1472–1553 German
The Crucifixion with the Converted Centurion, 1536
Oil on panel, 20″ × 13¾″
Samuel H. Kress Collection 1961.9.69

PAGE 41
After Rembrandt van Rijn
The Descent from the Cross, ca. 1655
Canvas, 56¼″ × 43¾″
Widener Collection 1942.9.61

PAGE 42
Jacopo Palma il Giovane, ca. 1548–1628 Venetian
Lamentation, ca. 1620
Oil on canvas, 52½″ × 42¾″
Given in memory of William E. Suida by
Bertina Suida Manning and Robert L. Manning

PAGE 45
South Netherlandish, 15th century
Pieta, ca. 1450/1475
Alabaster with traces of polychromy,
16½″ × 19¾″ × 9¼″
Patrons' Permanent Fund 1990.13.1

PAGES 46–47
Andrea Mantegna, 1431–1506 Paduan
The Entombment, 1465/1470
Engraving in brown; laid down, 11¾″ × 17⅜″
Patrons' Permanent Fund 1986.98.1

PAGE 48
Attributed to Fra Angelico
The Entombment
(see description for page 11)

PAGE 51
Workshop of Andrea Mantegna
Descent into Limbo, ca. 1475/1480
Engraving, 17⅜″ × 13⅞″
Gift of W. G. Russell Allen

PAGE 52
Bergognone
The Resurrection
(see description for back jacket)

PAGE 55
Follower of Rogier van der Weyden Netherlandish
Christ Appearing to the Virgin, ca. 1475
Oil on panel, 64⅛″ × 36⅝″
Andrew W. Mellon Collection 1937.1.45

PAGE 57
Domenico Campagnola, 1500–1564 Venetian
The Descent of the Holy Spirit, 1518
Engraving, 7⅜″ × 6⅞″
Rosenwald Collection 1943.3.2694

PAGE 64
Attributed to Fra Angelico
The Entombment (detail)
(see description for page 11)

List of Texts

Design and calligraphy by Martine Bruel

Composition: Jacket and title page in Palatino Regular, Italic and Bold

Text pages in Bembo Regular, Palatino Regular, Italic and Bold Italic

by Hamilton Phototype

Printed and bound by Dai Nippon Printing, Tokyo